CENTRAL MANCHESTER
HISTORY TOUR

First published 2018

Amberley Publishing
The Hill, Stroud,
Gloucestershire, GL5 4EP
www.amberley-books.com

Copyright © Jean &
John Bradburn, 2018
Map contains Ordnance Survey data
© Crown copyright and database right
[2018]

The right of Jean & John Bradburn
to be identified as the Authors
of this work has been asserted
in accordance with the Copyright,
Designs and Patents Act 1988.

ISBN 978 1 4456 7977 8 (print)
ISBN 978 1 4456 7978 5 (ebook)

British Library Cataloguing in
Publication Data.
A catalogue record for this book is
available from the British Library.

Origination by Amberley Publishing.
Printed in Great Britain.

INTRODUCTION

Although Manchester is renowned for being a Victorian city, our walk will take us from Roman Manchester through Georgian Manchester to the medieval centre, and, of course, passing the great Victorian buildings of the city along the way. We finish our walk at the site of the Peterloo Massacre.

We start at Manchester's birthplace: the site of the Roman fort at Castlefield. It was named Mamucium by the Romans, who built their fort here in AD 79 – the same year that Pompeii was destroyed. They chose this site to protect the routes from Chester to York and north to Lancaster and Carlisle. The site was chosen near the River Medlock and River Irwell, and a small community grew up around the fort.

After the Norman Conquest, the barony of Manchester came into the possession of Albert Grelley.

In 1227 the town received its first charter, and the fair was held on Acres Field (Saint Ann's Square today).

Manchester proved to be radical at a very early stage. In 1301 the Great Charter of Manchester gave rights to women. They could now trade in their own right and be members of a guild – privileges that were denied to women elsewhere. There were no restrictions on who could trade and from then we see the early signs of Manchester's free trade tradition.

It was near the Roman site that the Duke of Bridgewater chose to make Castlefield the terminus of his canal from Worsley to Manchester. The Bridgewater Canal opened in 1761 and has a special place in history as it was the first to be built in Britain without following an existing watercourse,

becoming a model for those that followed. Affectionately known as the 'Duke's Cut' after its owner Francis Egerton, 3rd Duke of Bridgewater, he revolutionised transport in this country and marked the beginning of the golden canal era. Nearby in Liverpool Road you will see Liverpool Road station, the country's first railway station. The rail link combined with the new canal system was instrumental in Manchester's industrial growth in the nineteenth century.

We then walk towards Georgian Manchester. Manchester was a stronghold of the Jacobites when Bonnie Prince Charlie marched south from Scotland in 1745 to try to claim his throne from George II. The Jacobites received limited support on their march, but upon reaching Manchester the would-be king managed to recruit 300 volunteers. These were formed into the Manchester Regiment and were mainly drawn from the town's unemployed. Charles Stuart never got to London; he was forced back to Scotland where he was ultimately defeated at Culloden.

We walk up Peter Street to see the Free Trade Hall (now a Radisson Hotel) – another proud example of Manchester's radical tradition. As you pass through Albert Square, go down Brazennose Street to see the statue of Abraham Lincoln.

As we walk down Deansgate we start to arrive in medieval Manchester. Manchester even had its own castle, a medieval fortified manor house, probably located on a bluff where the rivers Irk and Irwell meet. As you would expect, the town grew up close by – near the Collegiate Church and Chetham's. It is in this area that we find the city's oldest buildings. Here we will see Byrom's House and the Old Wellington Inn.

Manchester had a textile tradition even in medieval times. Flemish weavers settled in this area in the fourteenth century and brought their crafts with them. By 1800 fifty steam-powered cotton mills dominated the town – 'Cottonopolis' was taking shape.

Manchester's wealth came with a price: for men, women and children working at the mills the hours were long and the work was hard and dangerous.

Poor-quality houses were built to provide for the increasing population. These were crowded, squalid and encouraged disease. Unsurprisingly, a cholera epidemic hit Manchester in 1832. Manchester's slums became notorious. When Frederick Engels arrived in the city to work at his family's firm, he was horrified at the conditions of the working men and women. This resulted in his famous book *The Condition of the Working Class in England*, which was published in 1845. He met and became a lifelong friend of Karl Marx and together they published *The Communist Manifesto* in 1848. Pearson's Court, off Corporation Street, gives us a good idea of the poverty of the workers and their families.

Piccadilly is surrounded by modern buildings today and is an important transport hub for the city. It is the site of the Manchester Infirmary, which was erected in 1775 and demolished in 1909 to make way for sunken gardens. If you look down Portland Street you will see many fine warehouses. These have been described as the finest example of a Victorian commercial centre in the United Kingdom.

As we walk down Mosley Street, we see more of the buildings built in the Victorian age to reflect Manchester's growing wealth and prestige: the Portico, the Art Gallery and the Athenaeum. Arriving in St Peter's Square, we see the rear entrance to the Town Hall. Stop and reflect at the fine cenotaph created by Lutyens. It has been moved to its present position to accommodate the expansion of the city's Metrolink trams. It is fitting that it is placed near to scene of the infamous Peterloo Massacre (1819), reminding us of the loss of life in this square. The name Peterloo combines Manchester's traditional meeting place of St Peter's Fields with the Battle of Waterloo, fought four years earlier.

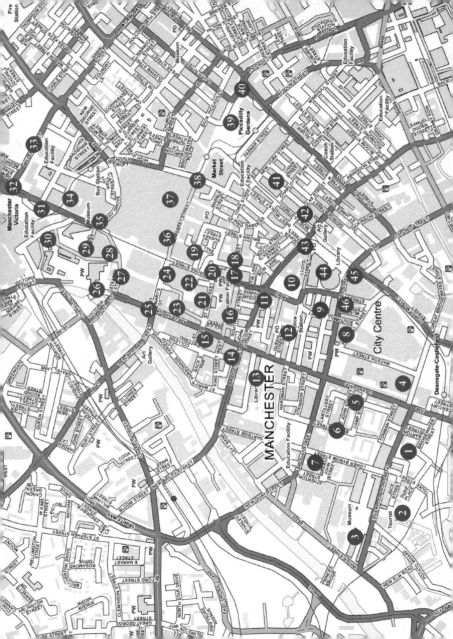

KEY

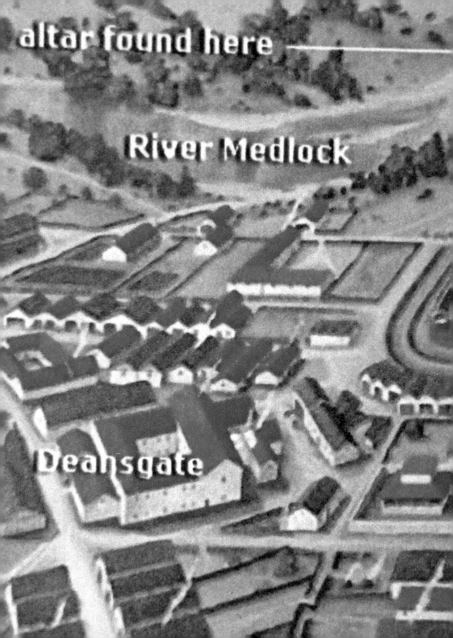

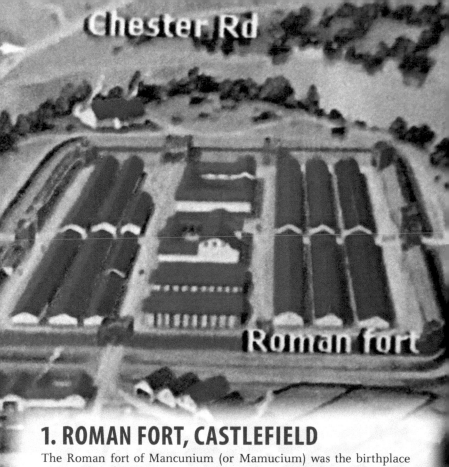

Chester Rd

Roman fort

1. ROMAN FORT, CASTLEFIELD

The Roman fort of Mancunium (or Mamucium) was the birthplace of modern Manchester. This artist's impression by Graham Sumner gives us an idea of what it may have looked like. It was a timber fort with earthen ramparts for an infantry of around 500 men. Numerous archaeological digs have taken place here and they revealed a great deal about the early history of the city. Castlefield has now been turned into a heritage park, with noticeboards explaining the historic importance of the area.

2. BRIDGEWATER CANAL BASIN, CASTLEFIELD, 1900

Nearby is the terminus of the Bridgewater Canal. The Duke of Bridgewater built his canal to transport his coal from Worsley to Manchester. By 1765 this goal had been achieved. He continued to develop the wharfs, building modern warehouses designed with hoists to transport the goods. These distinctive buildings can still be seen today. They have been modernised and now house offices, modern apartments, and lively bars and restaurants.

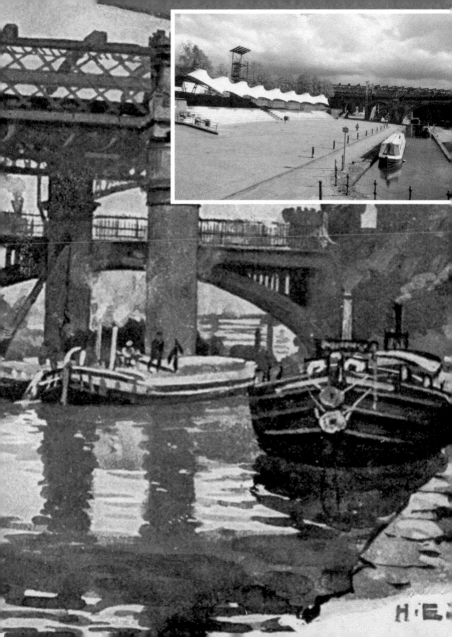

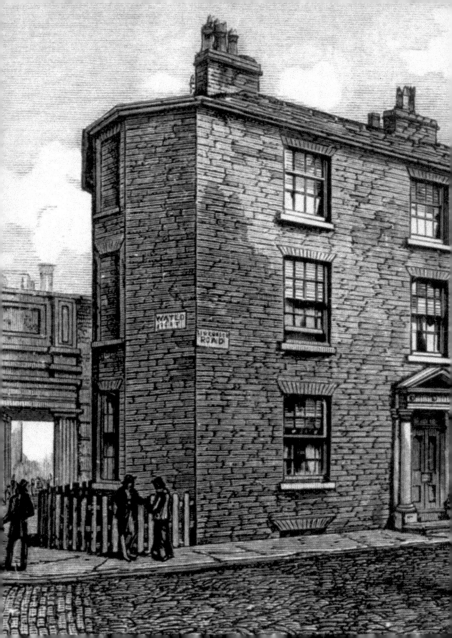

3. LIVERPOOL ROAD STATION, 1890

Manchester can claim to have been the place where the railway age began. It was the service established between Liverpool and Manchester that first demonstrated the feasibility of rail as a viable transport system. It opened to the public in 1830 and is now part of the Museum of Science and Industry. It was to this station that competitors in the Rainhill Trials arrived at after using a locomotive to pull passenger coaches between Liverpool and Manchester – George Stephenson's *Rocket* was the winner.

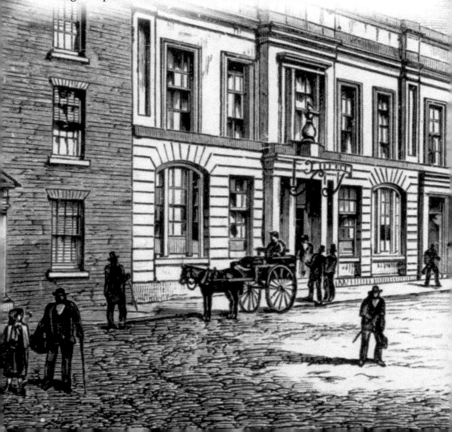

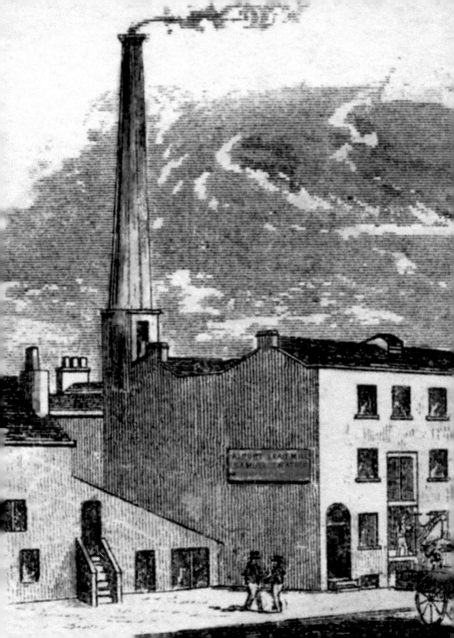

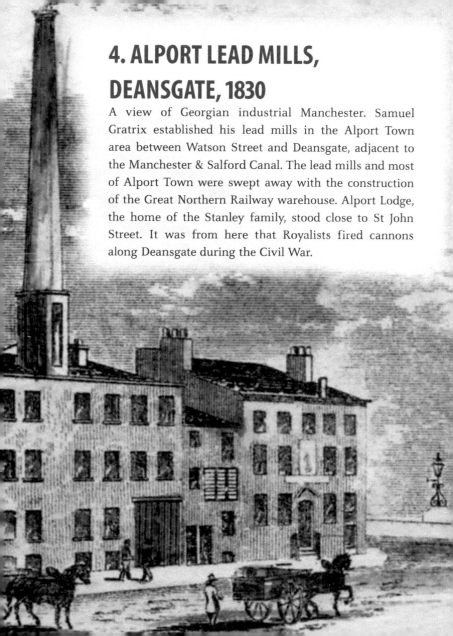

4. ALPORT LEAD MILLS, DEANSGATE, 1830

A view of Georgian industrial Manchester. Samuel Gratrix established his lead mills in the Alport Town area between Watson Street and Deansgate, adjacent to the Manchester & Salford Canal. The lead mills and most of Alport Town were swept away with the construction of the Great Northern Railway warehouse. Alport Lodge, the home of the Stanley family, stood close to St John Street. It was from here that Royalists fired cannons along Deansgate during the Civil War.

5. ST JOHN STREET, 1850

Still the finest street in Manchester, the only remaining complete Georgian terraces were built here between 1770 and 1830. We look down towards the site of St John's Church, which is now sadly demolished. Early residents represented a broad mix of occupations, but with the passage of time occupancy became almost exclusively connected with the medical and legal professions. Consultants and specialists still comprise the majority of occupants in St John Street.

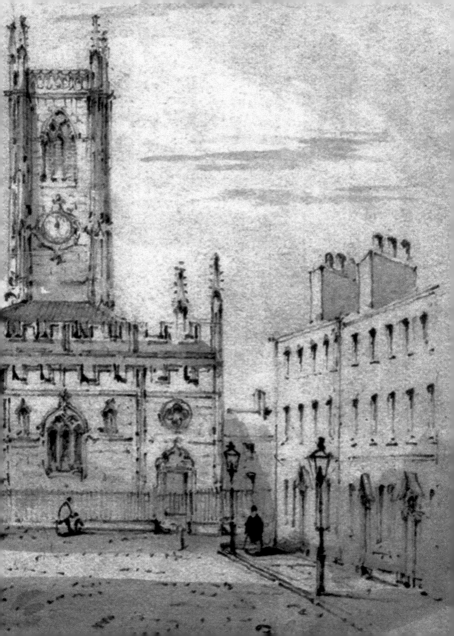

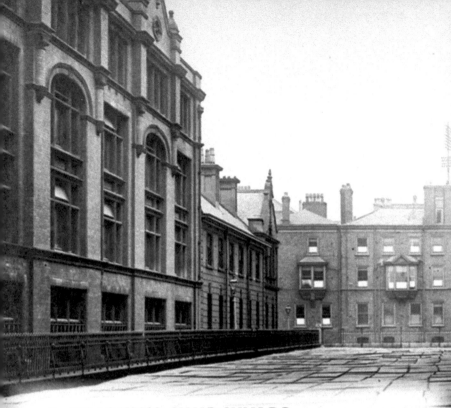

6. ST JOHN'S CHURCHYARD, BYROM STREET, 1914

This Georgian church was founded in 1768 by John Byrom's son Edward. He also built the first quay on the River Irwell, giving rise to the name of the nearby Quay Street. The churchyard contains the remains of a remarkable number of people associated with the rise of Manchester as a world industrial city. The church was demolished in 1931 and turned into attractive gardens. During the Jacobite rising this area was used by Bonnie Prince Charlie as a gun park.

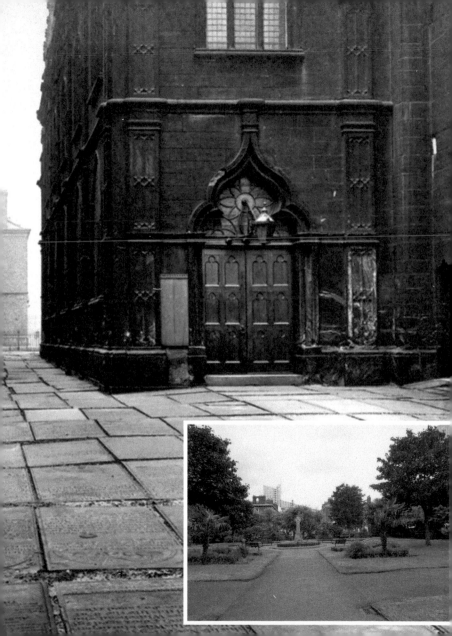

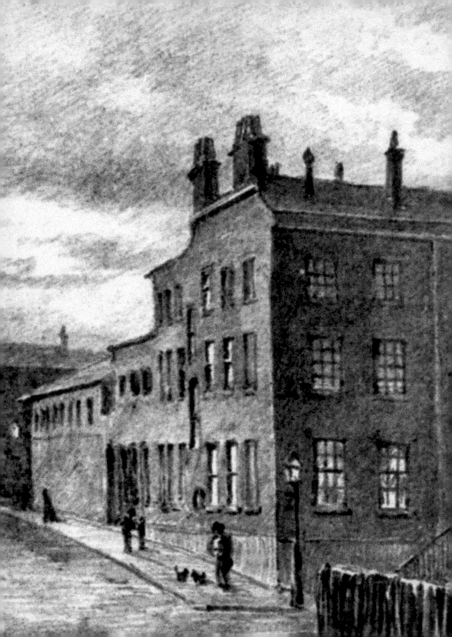

7. OWENS COLLEGE, QUAY STREET, 1880

Richard Cobden (1804–65), the politician and reformer, lived in this Georgian house on the corner of Quay Street and Byrom Street. It was later purchased under the will of John Owens, a wealthy textile merchant, and opened as Owens College in 1851. Later still, it became the Victoria University of Manchester. John Owens, his parents and brothers were buried in St John's Churchyard. In the 1770s the site was owned by the family of Edward Byrom – hence the name Byrom Street.

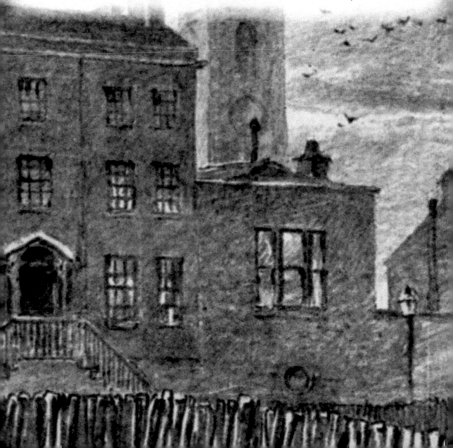

8. FREE TRADE HALL, PETER STREET, 1905

Richard Cobden gave land to build the original Free Trade Hall. The hall we see today was the third one built on this site. It was completed in 1856 and dedicated to free trade and all those who fought for the repeal of the Corn Laws. In 1940 the hall was damaged by a bomb and the inside was remodelled. It was opened as a concert hall in 1951, and became the home of the Hallé Orchestra until Bridgewater Hall was opened in 1996. The hall is now a fine hotel.

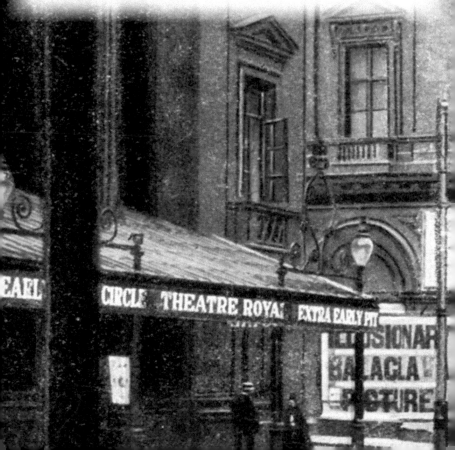

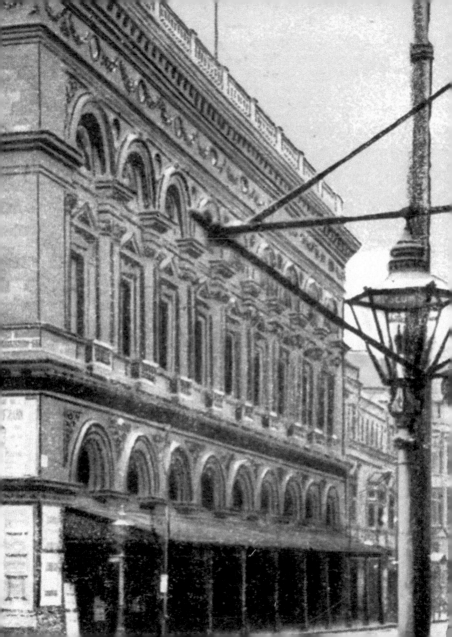

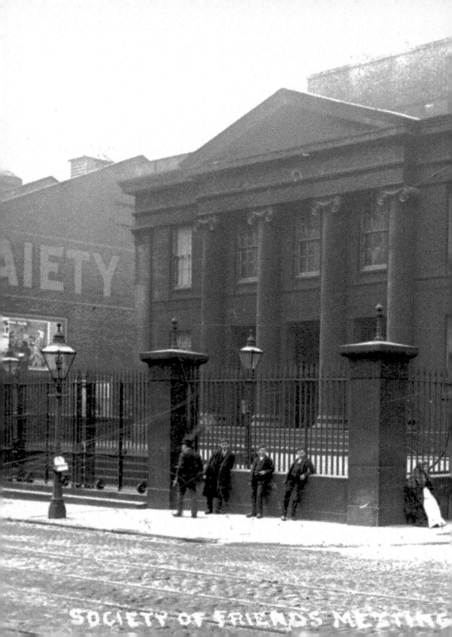

SOCIETY OF FRIENDS MEETING

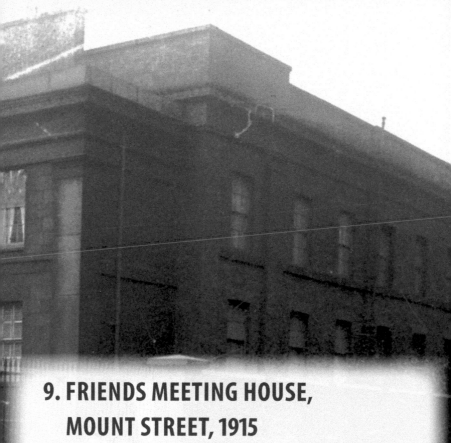

9. FRIENDS MEETING HOUSE, MOUNT STREET, 1915

The Quakers have existed in Manchester since the time of George Fox. Quakerism gained a considerable following in England and Wales. This fine building was designed in 1828 by Richard Lane, a Quaker architect – one of his pupils was Alfred Waterhouse. The cost of the building – £7,600 – was raised by subscription from local Quakers, one of whom was John Dalton, the famous chemist and discoverer of atomic theory who worshipped here for many years.

10. ALBERT SQUARE, KITCHENER'S PARADE, TOWN HALL, 1915

In March 1915 Lord Kitchener reviewed a parade of troops outside the Town Hall in Albert Square. During the visit, which only lasted ninety minutes, he saw 13,000 South East Lancashire troops, many of them far from battle ready. His famous poster 'Your Country needs YOU' resulted in 2,466,719 men volunteering between August 1914 and December 1915. Albert Square is still an important focal point for demonstrations and marches.

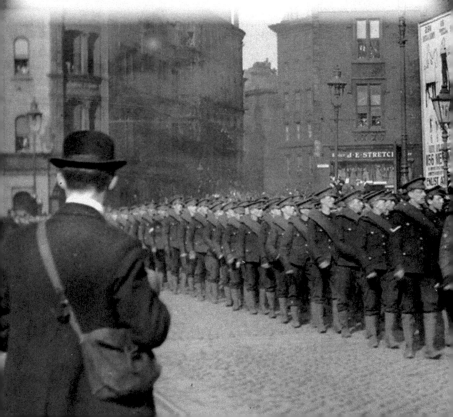

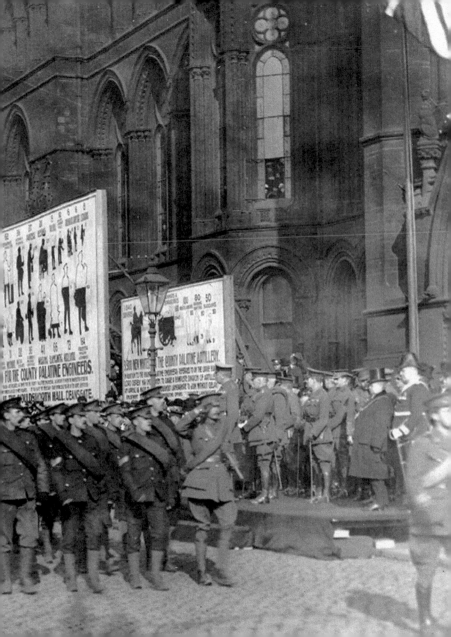

11. THOMAS DE QUINCEY, JOHN DALTON STREET, 1892

The author Thomas De Quincey was born here in 1785. He has become known for his work *Confessions of an English Opium Eater*. Along with his opium addiction, debt was also a problem. He became an acquaintance of Coleridge and Wordsworth. His acquaintance with Wordsworth led to him settling in 1809 at Grasmere in the Lake District. His home for ten years was Dove Cottage. This building became Princes Tavern and the office building is named De Quincey House today.

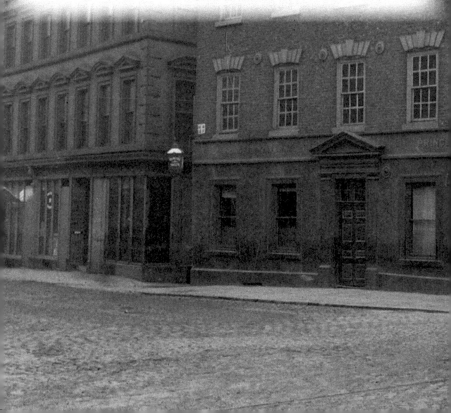

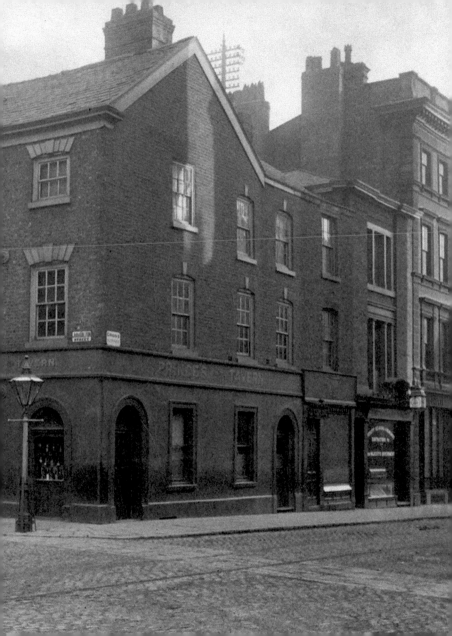

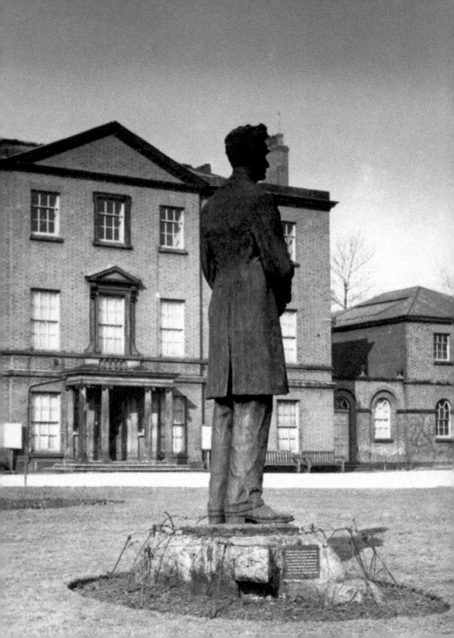

12. ABRAHAM LINCOLN STATUE, LINCOLN SQUARE

Barnard's bronze statue was presented to the city of Manchester and unveiled in Platt Fields in 1919. The ceremony was an unashamed celebration of Manchester's liberal values. Manchester was a very important ally to Abraham Lincoln's Union during the American Civil War. Manchester took a strong moral and political stance by choosing to boycott southern cotton in protest against the use of slave labour. This led to the Lancashire cotton famine. Lincoln wrote a letter to thank the people of Manchester for their support. The statue was moved to its current position in Lincoln Square in 1986.

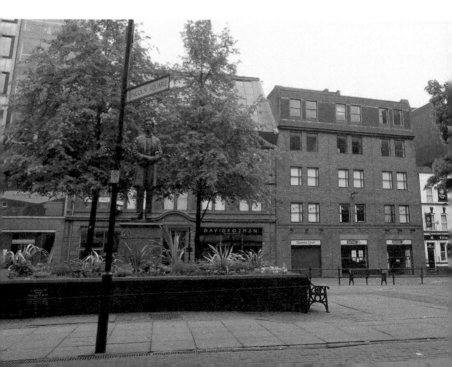

13. JOHN RYLANDS LIBRARY

John Rylands was born in St Helens in 1801. His family were cotton manufacturers. He quickly became the owner of the largest textile manufacturing concern in the United Kingdom, and was also Manchester's first multimillionaire. This fine library, built in red sandstone, was erected by his widow Enriqueta as a permanent memorial to her beloved husband. In 1890 she appointed Basil Champney as the architect. No expense was to be spared. It cost £230,000 and was not finished until 1899.

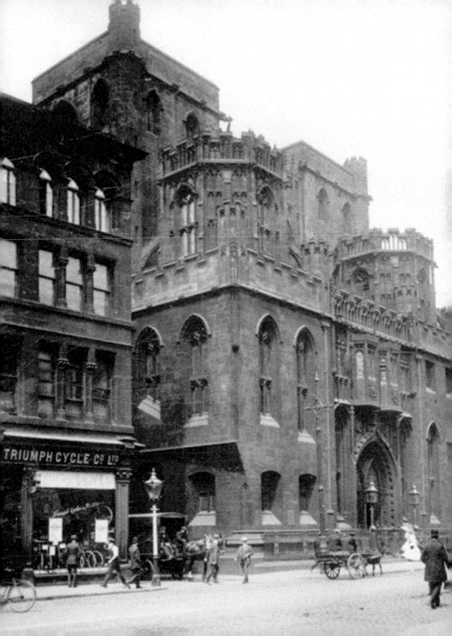

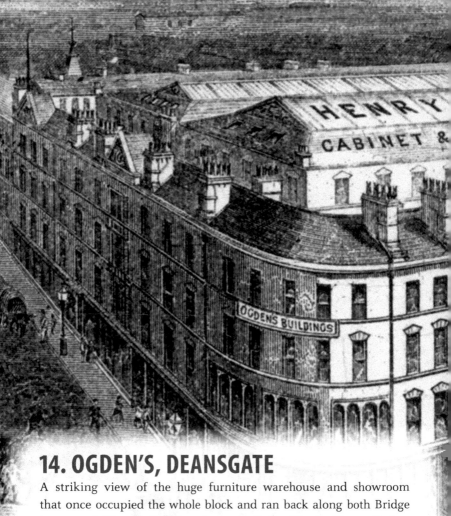

14. OGDEN'S, DEANSGATE

A striking view of the huge furniture warehouse and showroom that once occupied the whole block and ran back along both Bridge Street and King Street West. It was built in 1862 for Henry Ogden, cabinetmaker. The store attracted the many wealthy merchants of Manchester. We can still see parts of the original building today above Forsyth's music store.

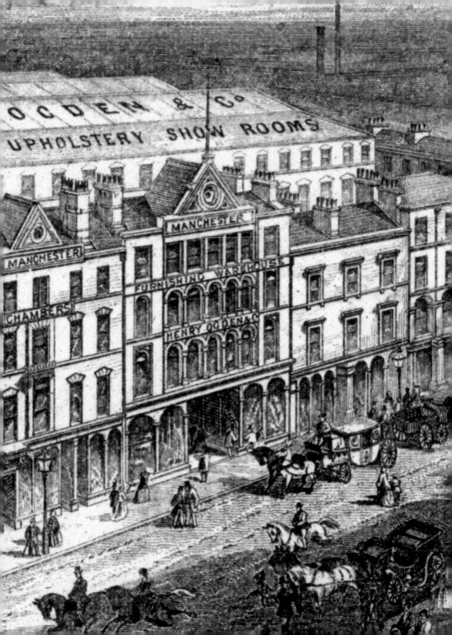

BY APPOINTMENT.

Kendal,
Milne
& Co.,
Manchester

Silk
Mercers
&
General
Furnishers,

TELEGRAMS :
"Kenmil,"
Manchester.

TELEPHONE :
1746,
Manchester.

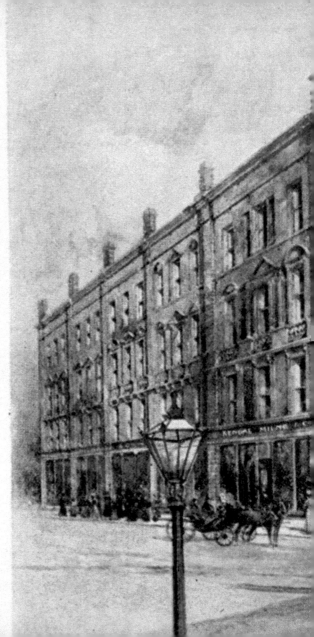

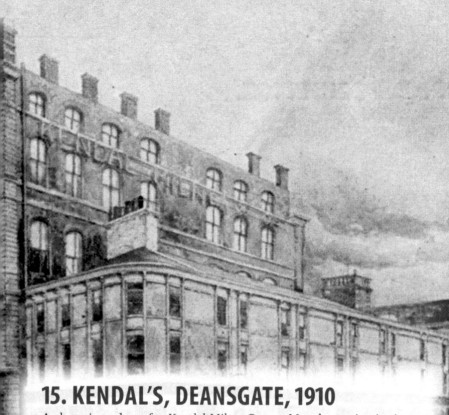

15. KENDAL'S, DEANSGATE, 1910

A charming advert for Kendal Milne. Once a Manchester institution, this is now a House of Fraser store. The shop was founded by John Watts in 1796. In 1835 the business was sold to three of Watts' employees. Thomas Kendal had trained as a draper in London, and James Milne and Adam Faulkner had both been apprenticed in the textile trade. This view shows the drapery department, which was on the opposite side of the road from the main store, where Waterstones stands today.

16. KING STREET, 1930

This image is looking down King Street towards Deansgate. The south part of this street is now mainly shops. On the right we can still see the last surviving Georgian mansion in central Manchester. It was built as a residence in 1736 by Dr Peter Waring and became a bank soon after his death in 1788. It is a branch of Jack Wills today. King Street is still a fashionable shopping street, although it now has a rival in Spinningfields.

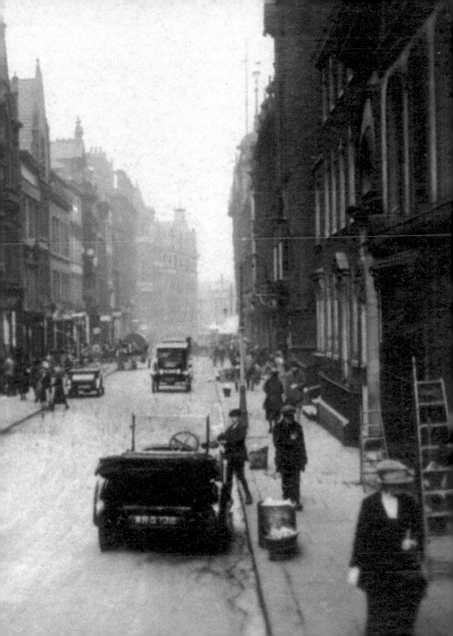

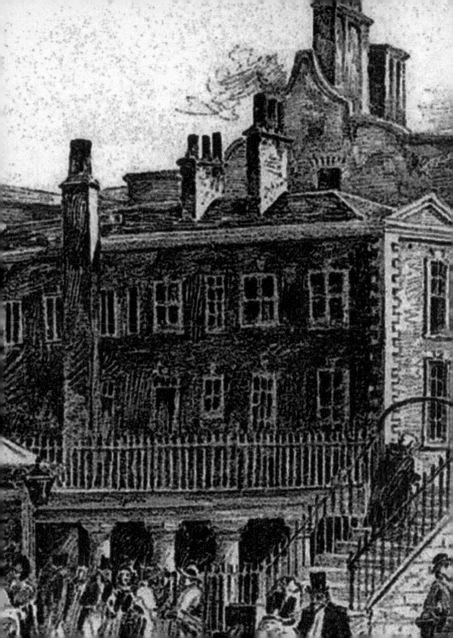

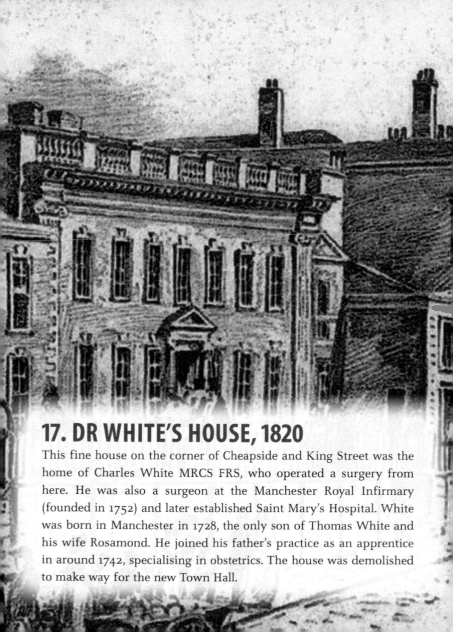

17. DR WHITE'S HOUSE, 1820

This fine house on the corner of Cheapside and King Street was the home of Charles White MRCS FRS, who operated a surgery from here. He was also a surgeon at the Manchester Royal Infirmary (founded in 1752) and later established Saint Mary's Hospital. White was born in Manchester in 1728, the only son of Thomas White and his wife Rosamond. He joined his father's practice as an apprentice in around 1742, specialising in obstetrics. The house was demolished to make way for the new Town Hall.

18. OLD TOWN HALL, 1860

To reflect Manchester's new wealth, the old Town Hall was built in 1822 on the corner of Cross Street. Designed by Francis Goodwin in the Grecian style, it was strongly influenced by his patron, John Soane. Next door, on the right, we can just see the York Hotel, the site of anti-Corn Law meetings and where Manchester's first borough council met. As the size and wealth of the city grew even greater, a larger building was required and the Town Hall we see today was built in Albert Square.

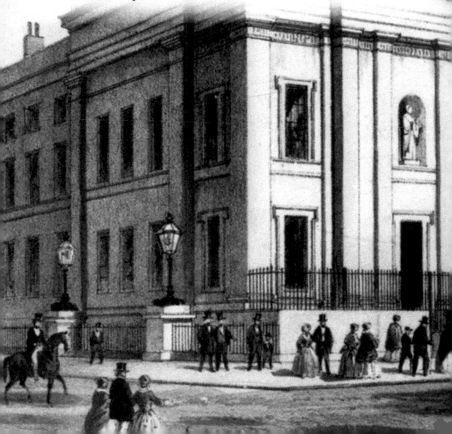

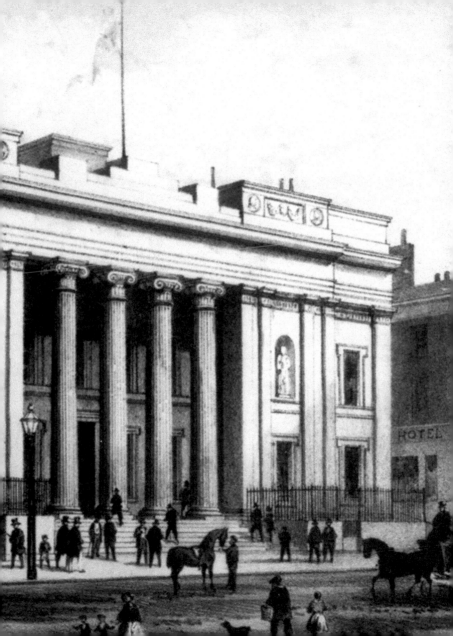

19. CROSS STREET CHAPEL, 1890

This is the home of the Unitarian Church in Manchester. Unitarianism as an organised church grew out of the Protestant Reformation in the sixteenth century. The church was wrecked by a Jacobite mob in 1715. In 1828 William Gaskell, husband of the novelist Elizabeth Gaskell, became the minister. The fine building we see in this photo was destroyed during a Second World War air raid in December 1940. A new building was constructed in 1959 and the present structure dates from 1997.

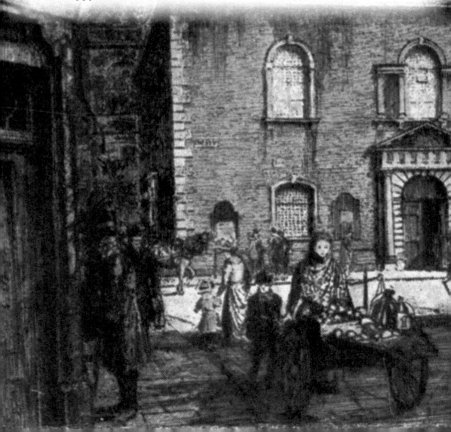

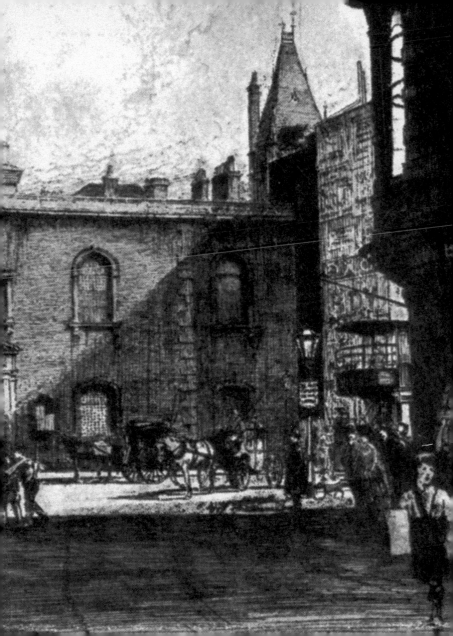

20. CROSS STREET, 1941

A fine view of Cross Street looking towards King Street during the Second World War. We see the site of the old Town Hall in King Street on the right and St Ann Street on the left. The double-decker tramcar – No. 42 – is on its way to West Didsbury. On Cross Street we now see the new Metrolink trams.

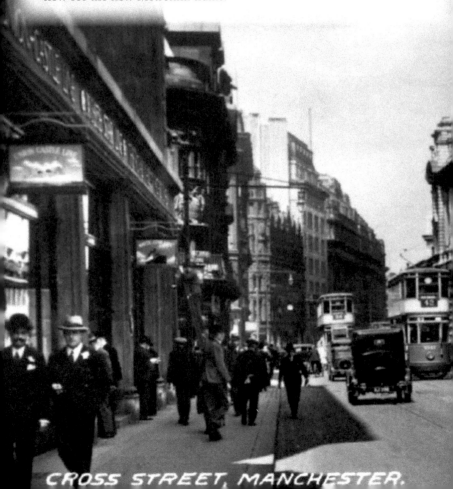

CROSS STREET, MANCHESTER.

21. ST ANN'S SQUARE AND CHURCH, 1741

A fine view of the Georgian square, which was originally called Acres Field. A fair was held here from 1227 in the days of Henry III. In 1709 Lady Ann Bland laid the foundation stone of St Ann's Church. In 1712 the church was consecrated by the Bishop of Chester, and John Wesley preached here in 1738. In 1745 Charles Edward Stuart, the Young Pretender, rode into the square and reviewed his troops. It has since become the most fashionable shopping district in Manchester.

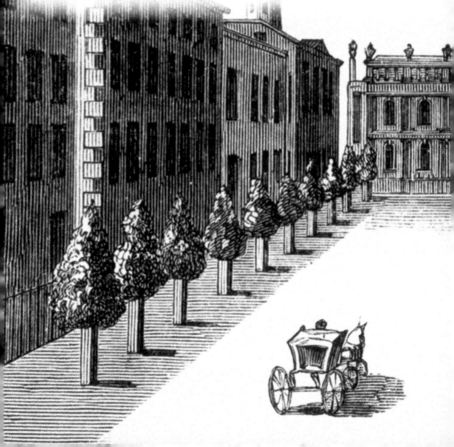

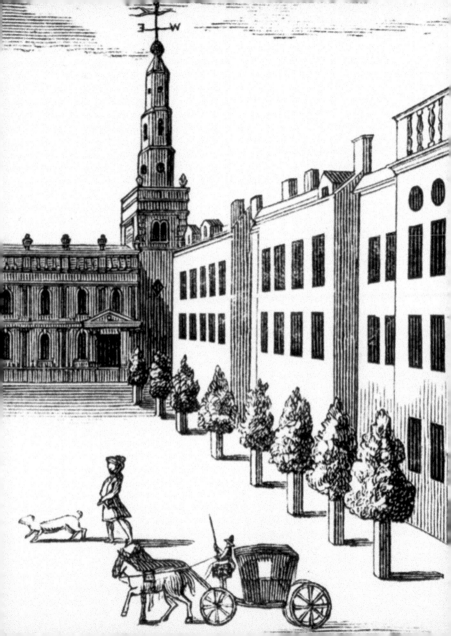

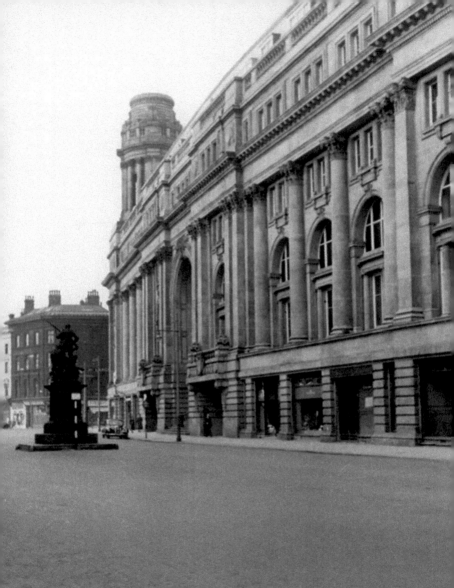

22. ROYAL EXCHANGE BUILDING FROM ST ANN'S SQUARE, 1955

The Last Shot Memorial is on the left, commemorating those who died during the Boer War in South Africa between 1899 and 1902. Today the building houses the magnificent Royal Exchange Theatre, which was opened by Laurence Olivier on 15 September 1976. It is a pure theatre-in-the-round and well worth going inside to see how the interior has been restored.

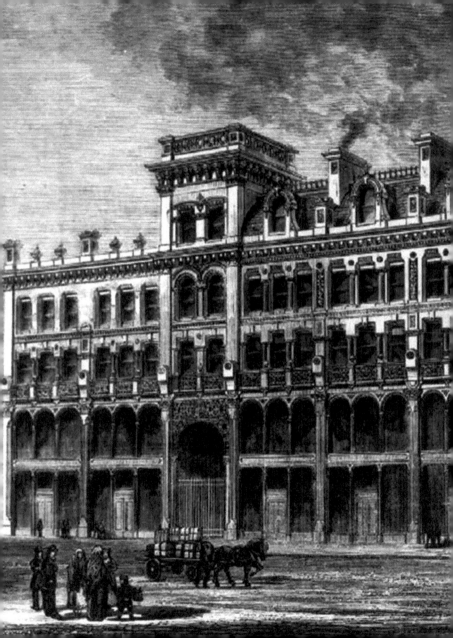

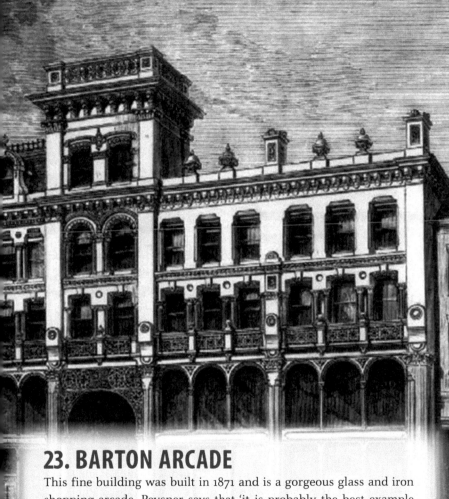

23. BARTON ARCADE

This fine building was built in 1871 and is a gorgeous glass and iron shopping arcade. Pevsner says that 'it is probably the best example of cast iron and glass roofed arcade anywhere in the country'. It is believed to be influenced by the Galleria Vittorio Emanuele in Milan. Everything is light and airy, and there are three tiers of balconies. A Manchester treasure.

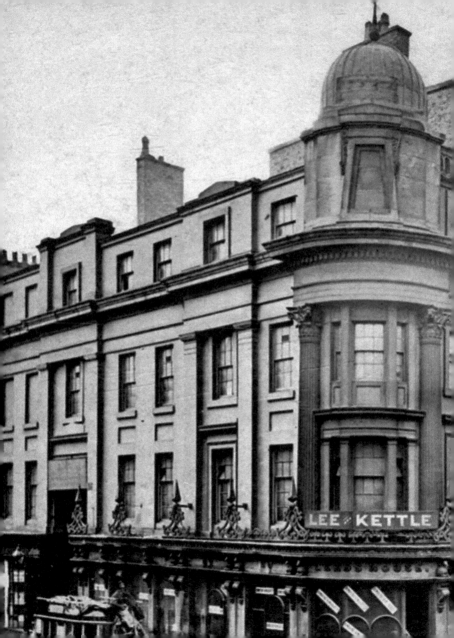

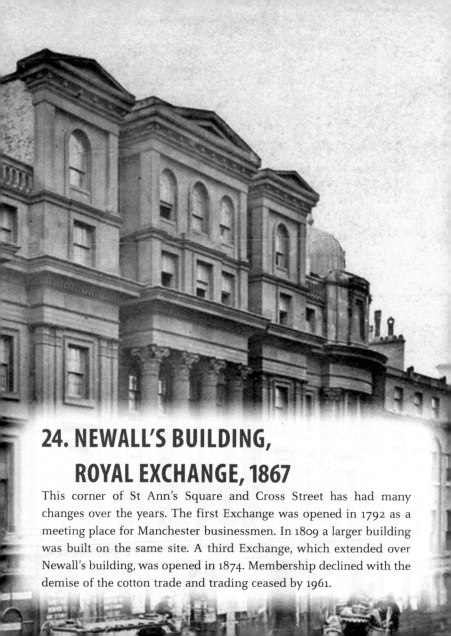

24. NEWALL'S BUILDING, ROYAL EXCHANGE, 1867

This corner of St Ann's Square and Cross Street has had many changes over the years. The first Exchange was opened in 1792 as a meeting place for Manchester businessmen. In 1809 a larger building was built on the same site. A third Exchange, which extended over Newall's building, was opened in 1874. Membership declined with the demise of the cotton trade and trading ceased by 1961.

25. ST MARY'S GATE

Between 1901 and 1949 Manchester Corporation Tramways was the municipal operator of electric tram services in Manchester. Here we see the huge crowds watching the laying of the tracks. The first section of the reconstructed tramway – between Albert Square and Cheetham Hill – was opened for electric traction on 7 June 1901. Reconstruction and electrification was completed by 1903, and the last horse trams within the city ran in that year.

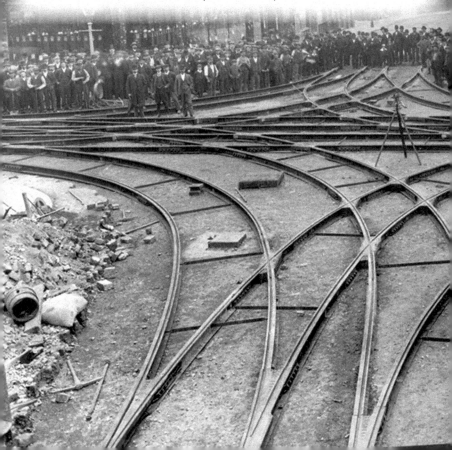

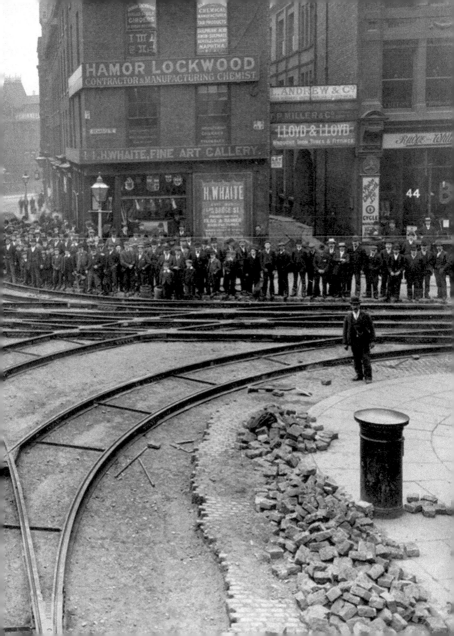

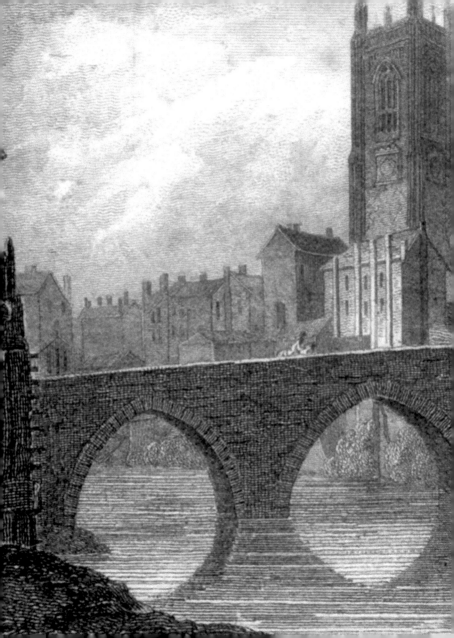

26. CATHEDRAL AND SALFORD OLD BRIDGE, 1800

We are now in the medieval centre of Manchester. This was the first stone bridge to be built across the River Irwell. In 1800 the cathedral was still known as the Collegiate Church. It was built in 1421 and consists chiefly of impressive late Perpendicular English architecture. The Collegiate Church was the parish church for a huge area. It was the only choice for the poor of Manchester, so, for financial reasons, many people were married en masse, with the vicar performing the marriage act to numerous couples at once.

27. CATEATON STREET, 1750

The Jacobite poet John Byrom lived here, author of the famous hymn 'Christians Awake'. Here we see the house in the snow on Christmas Eve in 1750. The hymn was written as a Christmas present for his daughter Dolly and is a wonderful hymn to be sang on Christmas morning. Although he was known as a Jacobite, he was lukewarm towards Charles Edward Stuart on his entry into Manchester in 1745. This part of town has now transformed into a modern shopping centre.

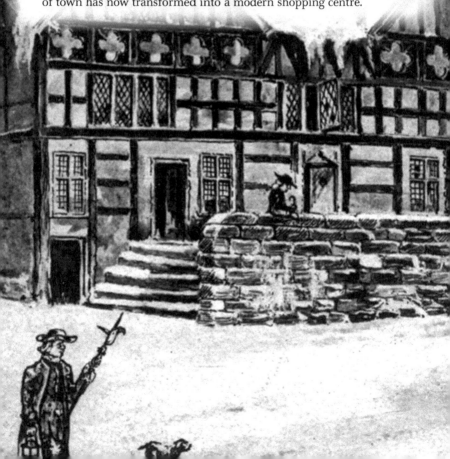

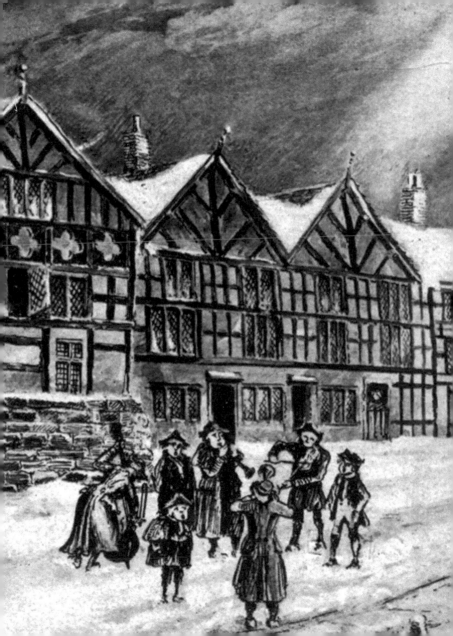

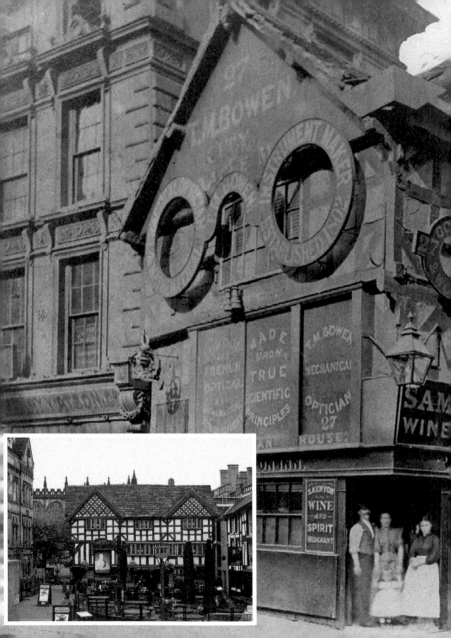

28. OLD WELLINGTON INN

This fine half-timbered pub is the oldest building of its kind in Manchester. It was built in 1552 next to the market square in an area known as the Shambles. The premises were licensed in 1862 and became the Vintners Arms, then the Kenyon Vaults and later the Old Wellington Inn. After the IRA bomb an ambitious plan was formed to move the structure, as Manchester could ill afford to lose one of its oldest buildings. This feat of engineering was a great success and it now stands close to Manchester Cathedral.

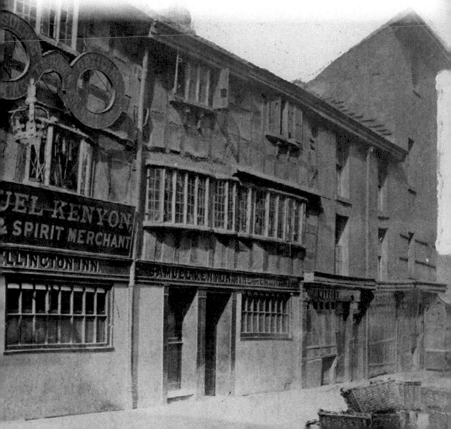

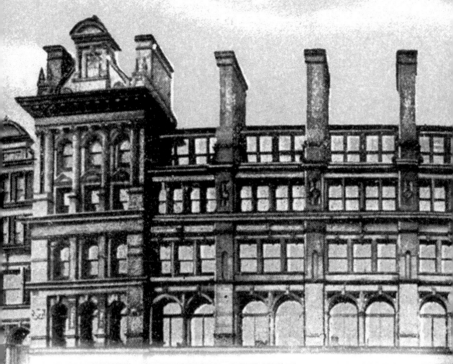

29. CORN EXCHANGE

The first Corn Exchange was built on this site in 1837. It was demolished in 1897 and replaced in two sections between 1897 and 1903. Before 1837 it traded from Hanging Ditch. In its heyday, the Corn & Produce Exchange was the gathering spot for thousands of traders from all over the region. This continued until the economic depression of the 1920s and 1930s. Following the Second World War, trade gradually declined and the trading floor fell into disuse. It is now home to a variety of restaurants.

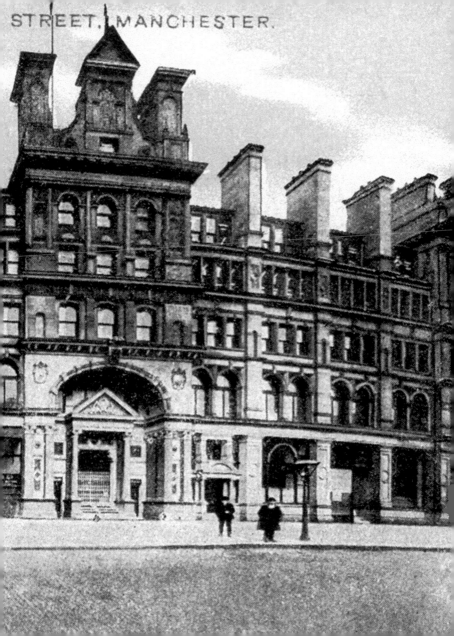
STREET, MANCHESTER.

30. LONG MILLGATE

This was originally known as Old Millgate. The town's major corn-grinding watermill had existed here on the banks of the River Irk since 1282, and Millgate is therefore widely accepted as meaning 'the way to the mill'. It was later extended to become Long Millgate. The Sun Inn became the haunt of poets and authors, giving it the nickname 'Poets' Corner'. Today the piece of land bounded by Long Millgate, Todd Street, Corporation Street and Fennel Street contains the iconic National Football Museum building.

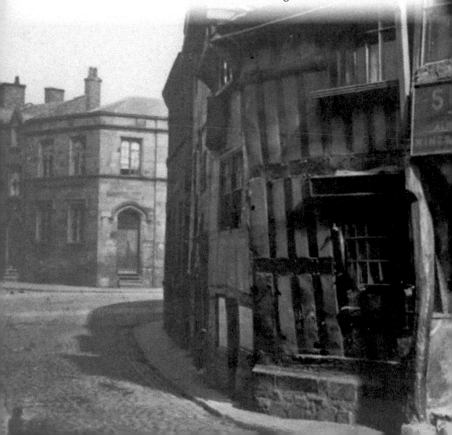

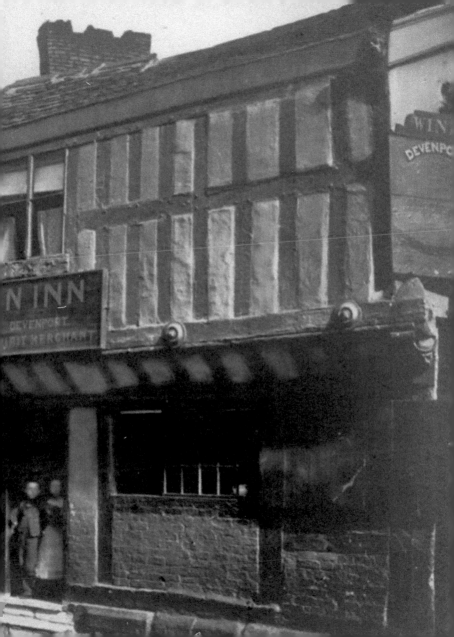

31. CHETHAM'S

The school is built on the site of Manchester Castle. Medieval Manchester grew around the manor house and the parish church and was originally built around 1421 as a priests' college attached to the Collegiate Church. They are the best preserved buildings of their type and date in the country. In 1653 the wealthy merchant Sir Humphrey Chetham left instructions in his will for the buildings to become a charity school or 'hospital' and library. It was the setting for Engels when he was researching *The Condition of the Working Class in England*, and it was here that he formed his lifelong friendship with Karl Marx.

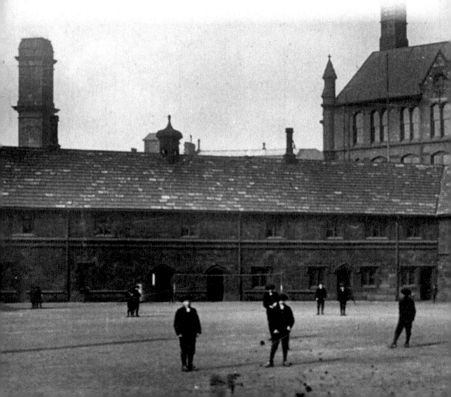

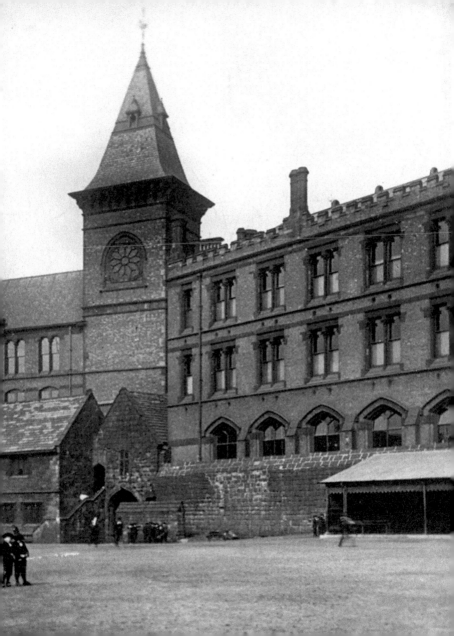

32. VICTORIA STATION

Victoria station was opened in 1844 by the Liverpool & Manchester Railway. It was designed by Robert Stephenson in the Italianate style. The long stone baroque elevation is described by Pevsner as unexciting, but the attractive canopy showing the destinations is very appealing. Queen Victoria gave permission for the station to be named after her. It was later enlarged and soon became one of the largest passenger stations in Britain.

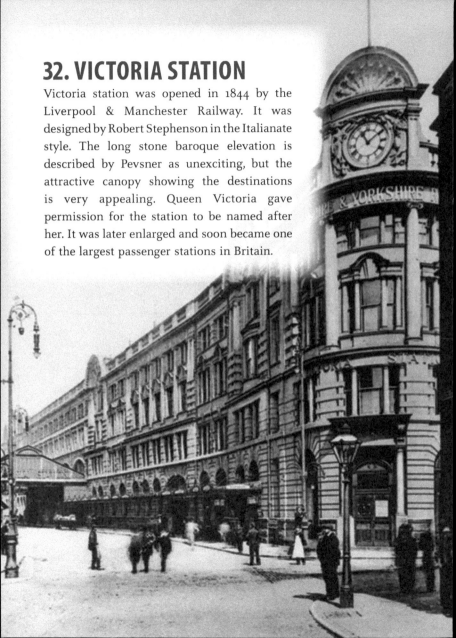

33. MILLER STREET

In 1780 Richard Arkwright began construction of Manchester's first cotton mill in Miller Street, next to Angel Meadow. This was the first example of a large purpose-built mechanised cotton-spinning mill in Manchester and it put the city at the forefront of the Industrial Revolution. Miller Street was badly damaged in the Christmas Blitz between 22 and 24 December 1940. The area has long been the headquarters of the Cooperative Wholesale Society and many of its modern buildings can be seen today.

34. PEARSON'S COURT

As you walk down Corporation Street today it is hard to imagine the squalid housing that existed here. 'The houses of the poor are generally built back to back, having therefore only one outlet, no yard, no privy and no receptacle for refuse. Consequently the narrow, unpaved streets, in which mud and water stagnate, become the common receptacles of offal and ordure. Often low, damp, ill ventilated cellars exist beneath the houses ... The streets, in the district are generally unsewered and the drainage is consequently superficial.'

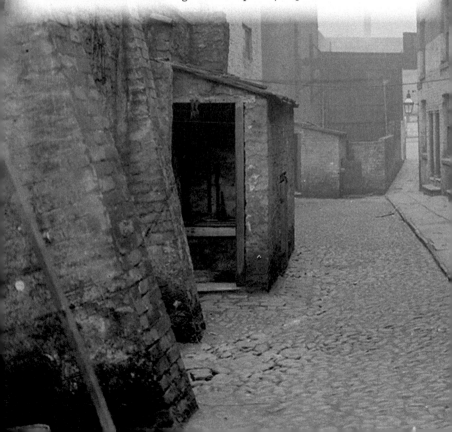

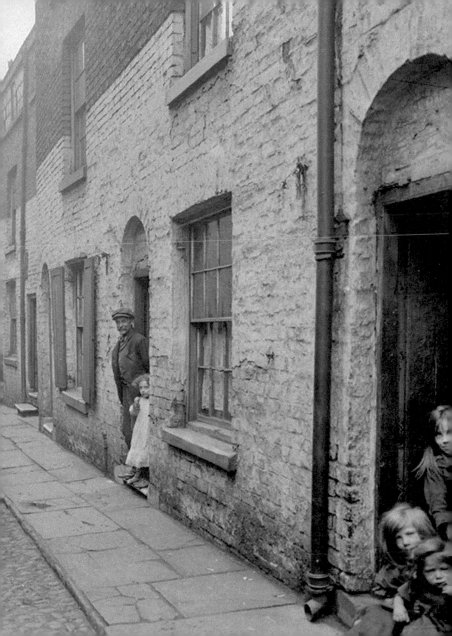

35. THE PRINTWORKS FROM HANGING DITCH, 1930

Hanging Ditch takes its name from the ancient watercourse that ran beneath the road connecting the rivers Irk and Irwell. In 1600 the Hanging Ditch was condemned as an unsanitary open sewer, and in the following years the ditch was culverted and the bridge buried and built over. The medieval bridge can still be seen below the cathedral's visitor centre. The Printworks building claimed to be the newspaper headquarters of Great Britain. In 1959, Roy Thomson bought a controlling interest and changed the name to Thomson House. It is now the home to a cinema, bars and restaurants.

36. MARKET STREET FROM CROSS STREET, 1900

This is shown as Market Street Lane on the 1650 map of the town, and led from the medieval market out into open countryside. This area, known as Market Place, would have been full of market stalls selling flowers, fruit, vegetables and poultry. This view from 1900 shows what an elegant shopping street it became. It was taken by the Royal Exchange on the corner of Cross Street. The shops were all demolished to build the Arndale Centre in 1972. In 1996 this area of the city was devastated by an IRA bomb.

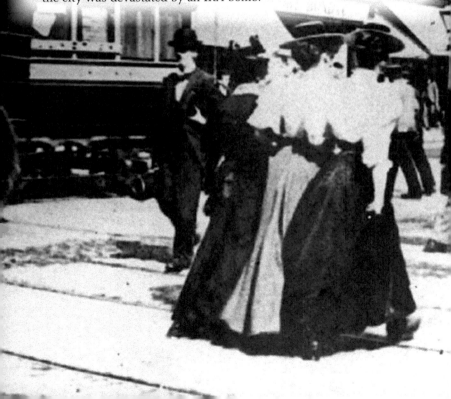

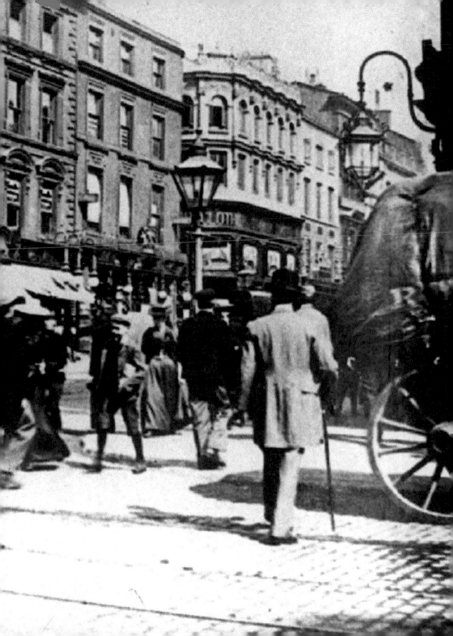

PALACE IN

37. PALACE INN MARKET STREET LANE, 1820

This elegant house was on the north side of what is now Market Street. In 1745 Charles Edward Stuart attempted to regain the British throne for the exiled House of Stuart. When Bonnie Prince Charlie arrived in Manchester he lodged at Mr Dickenson's house in Market Street Lane and it became known afterwards as 'The Palace'. Some 300 recruits joined the invaders and were named the Manchester Regiment. The house later became an inn, which we see here in 1820 – how very different from the Arndale Centre we see today.

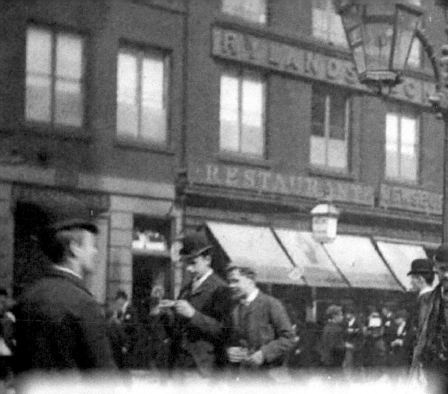

38. MARKET STREET FROM FOUNTAIN STREET, 1900

A very busy scene in 1900. The corner is now dominated by Debenhams. Rylands building was designed in 1932 in an art deco style. It was originally built as a warehouse by Rylands' textile company, which was founded by John Rylands. He was Manchester's first multimillionaire and employed 15,000 people in his seventeen mills and factories. His wife ensured that his name would live on forever in Manchester when she founded the John Rylands Library on Deansgate.

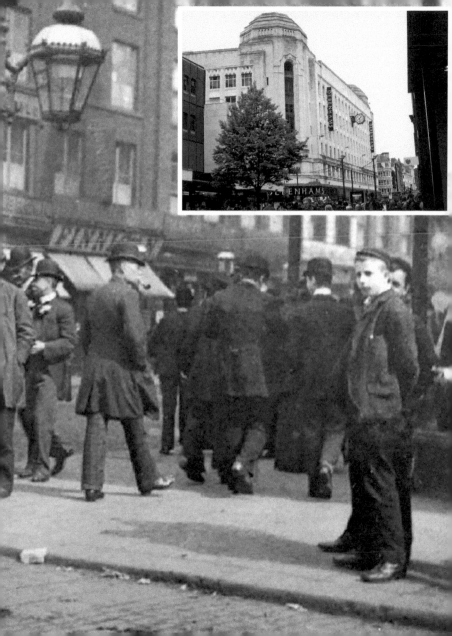

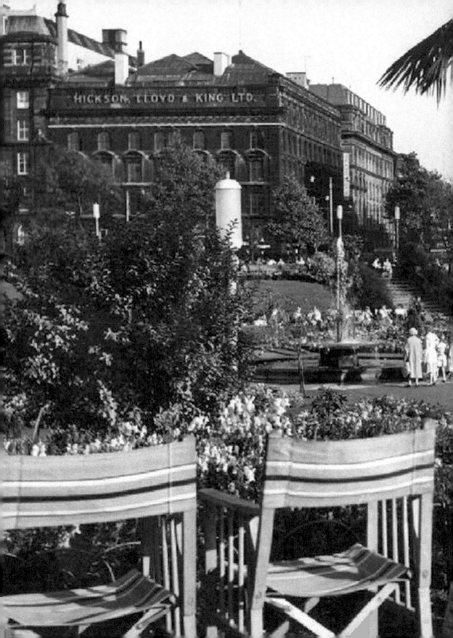

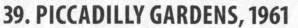

39. PICCADILLY GARDENS, 1961

Before 1755 this area, originally occupied by water-filled clay pits, was called the Daub Holes. The lord of the manor donated the site and the pits were replaced by a fine ornamental pond. The gardens are full of flowers and palm trees, with a traditional fountain in the centre. The woman here could be on the French Riviera. The gardens were redeveloped brutally in 2001 and there are now plans to remove the hated concrete wall, upgrade the grassed area and lighting, plant more trees, boost maintenance and open a new row of restaurants to replace the wall in order to return the gardens to their former glory.

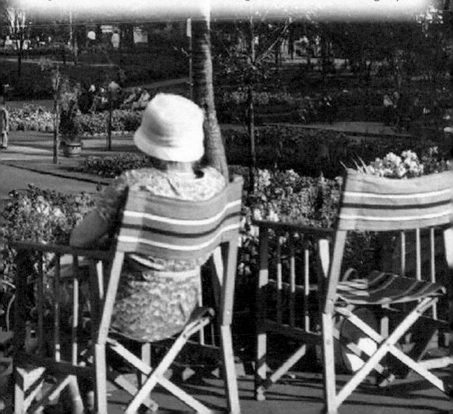

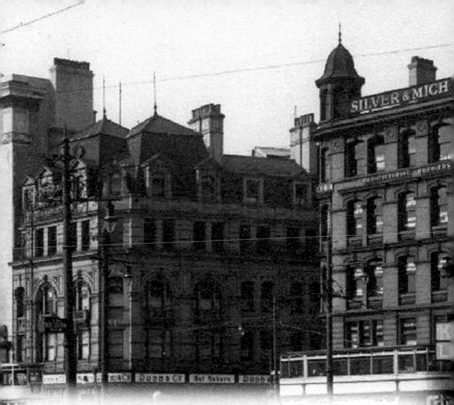

40. PICCADILLY, 1936

A view of Piccadilly taken from Portland Street, with Wellington's statue seen standing proud in the centre. Piccadilly was the site of the original Manchester Infirmary, which was demolished in 1909. The statue of Arthur Wellesley, Duke of Wellington, is in the foreground. The statue was designed by Matthew Noble and is much larger than life-sized at 13 feet high. It shows him in later life 'dressed in a frock-coat with military decorations' speaking in the House of Lords, with his military despatches at his feet. The monument was a controversial one, partly because public opinion favoured an equestrian statue.

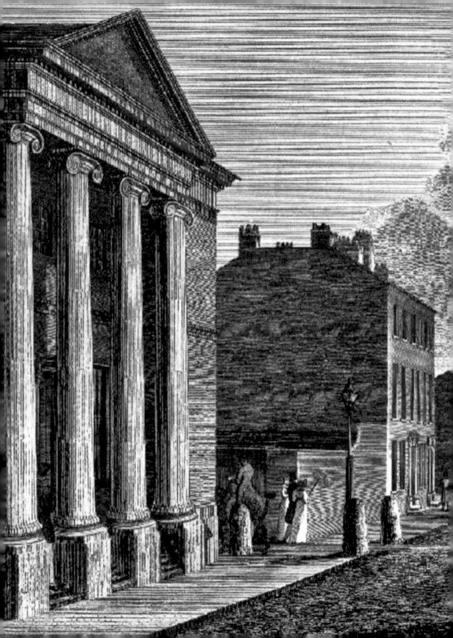

41. PORTICO LIBRARY, MOSLEY STREET, 1824

An elegant view down Mosley Street. We see the Portico Library and the fine church beyond. It was built in Greek revival style and was established as a result of a meeting of Manchester businessmen in 1802 that resolved to found an 'institute uniting the advantages of a newsroom and a library'. The subscription library remains upstairs, with its entrance on Charlotte Street. St Peter's Church was built in 1788 to serve the people who settled here on the outskirts of the relatively small Georgian town of Manchester. Built in the neoclassical style by James Wyatt, it was sadly demolished in 1907.

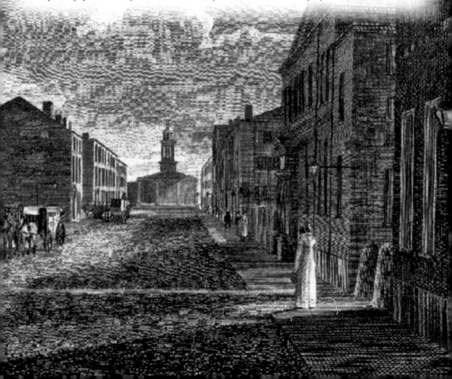

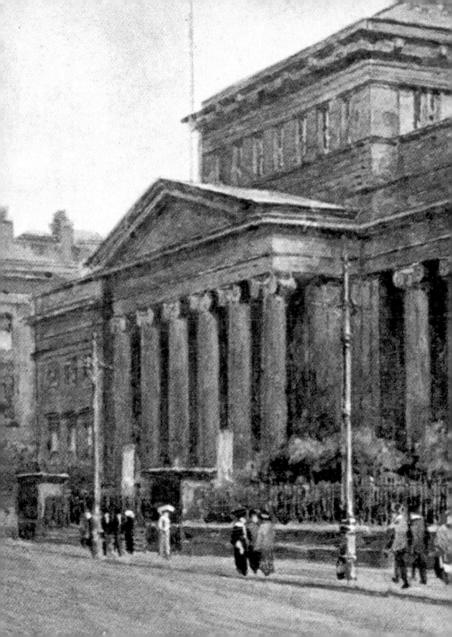

42. ART GALLERY, MOSLEY STREET

Another fine building. Designed by the young Charles Barry in the Grecian style, it was originally built for the Royal Manchester Institution between 1824 and 1835. The Athenaeum is around the corner in Princess Street, which was built by Charles Barry in the Italian palazzo style. Long used as an extension to the gallery, they are linked by a glass atrium. The gallery is best known for its world-famous Pre-Raphaelite paintings; the collection also includes British and European art from the seventeen century right up to the present day.

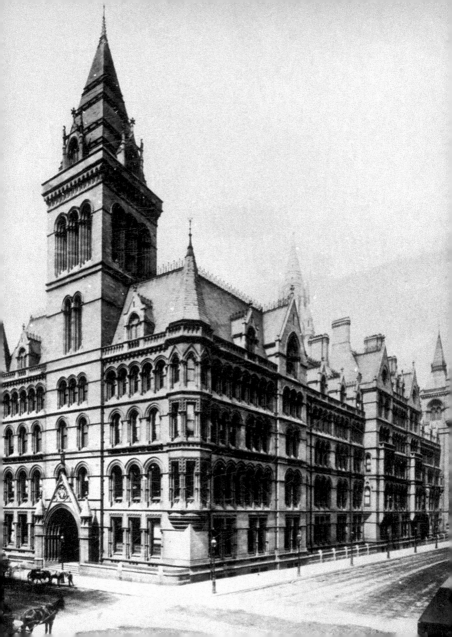

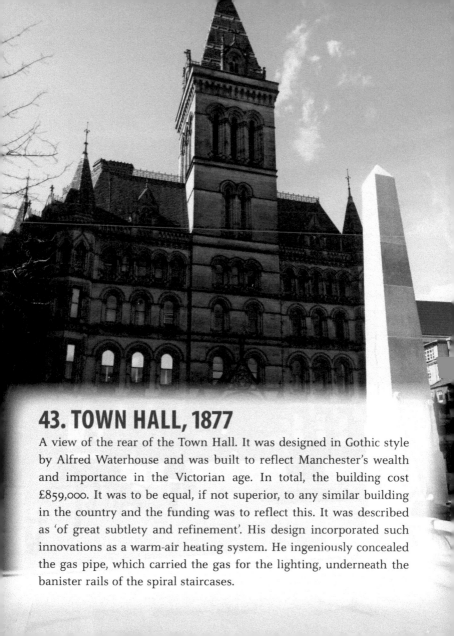

43. TOWN HALL, 1877

A view of the rear of the Town Hall. It was designed in Gothic style by Alfred Waterhouse and was built to reflect Manchester's wealth and importance in the Victorian age. In total, the building cost £859,000. It was to be equal, if not superior, to any similar building in the country and the funding was to reflect this. It was described as 'of great subtlety and refinement'. His design incorporated such innovations as a warm-air heating system. He ingeniously concealed the gas pipe, which carried the gas for the lighting, underneath the banister rails of the spiral staircases.

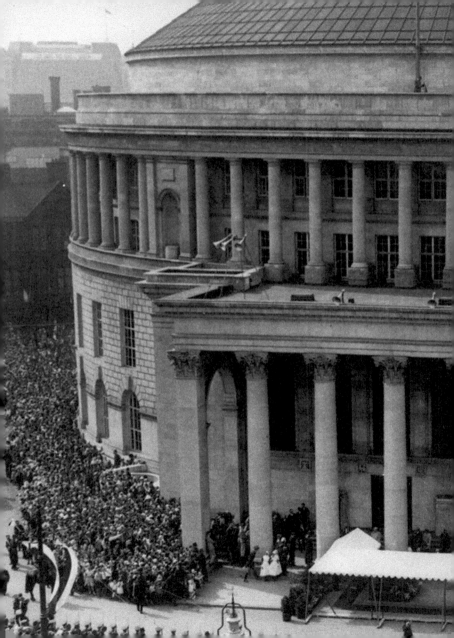

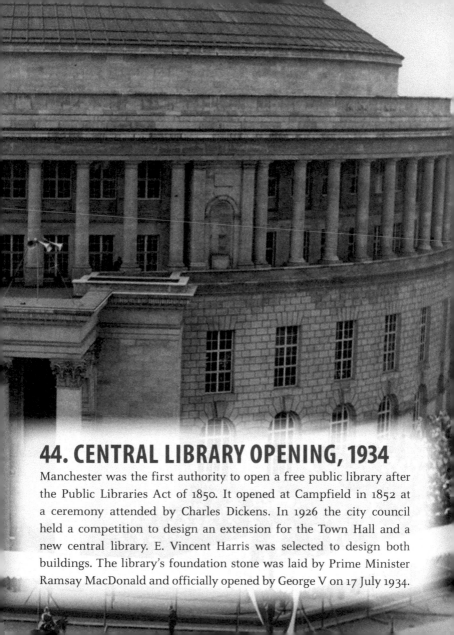

44. CENTRAL LIBRARY OPENING, 1934

Manchester was the first authority to open a free public library after the Public Libraries Act of 1850. It opened at Campfield in 1852 at a ceremony attended by Charles Dickens. In 1926 the city council held a competition to design an extension for the Town Hall and a new central library. E. Vincent Harris was selected to design both buildings. The library's foundation stone was laid by Prime Minister Ramsay MacDonald and officially opened by George V on 17 July 1934.

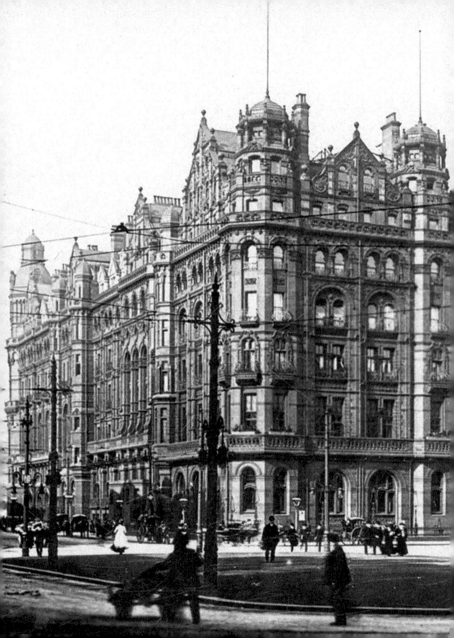

45. MIDLAND HOTEL

Opened in September 1903, it was built by the Midland Railway to serve Manchester Central railway station. It was designed by Charles Trubshaw in a highly individual Edwardian baroque style, clad in red brick, brown terracotta and several varieties of polished granite to withstand the polluted environment of Manchester. It was here in 1904 that Charles Rolls met Henry Royce, leading to the formation of Rolls-Royce in 1904.

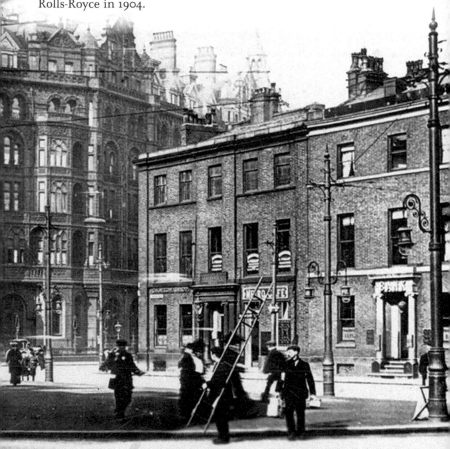

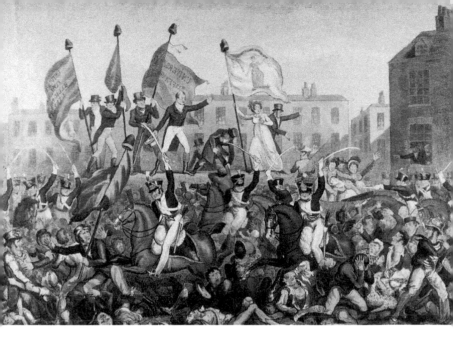

46. PETERLOO MASSACRE, SAINT PETER'S FIELD, 1819

This is the site of the infamous Peterloo Massacre. The introduction of the Corn Law in 1804 restricted the import of corn and brought deep suffering to the working classes as bread became expensive. Trouble had been brewing for some years in Manchester. On the morning of 16 August 1819 crowds began to assemble from all over the area, often walking long distances. Troops were called in to disperse the crowd. What should have been a peaceful meeting to appeal for change turned into a massacre when the yeomanry charged the gathering. Eleven people were reported killed and 140 injured in the resulting chaos.